THERE IS NO BEGINNING OR END...
YESTERDAY IS HISTORY.

TOMORROW IS A MYSTERY.

BUT TODAY, TODAY IS A GIFT.

Wet Dreams

Tyree Morris

authorHOUSE®

AuthorHouse™
1663 Liberty Drive
Bloomington, IN 47403
www.authorhouse.com
Phone: 1-800-839-8640

First published by AuthorHouse 1/25/2010

ISBN: 978-1-4490-6645-1 (sc)

Printed in the United States of America
Bloomington, Indiana

This book is printed on acid-free paper.

WHEN YOU EXPLODE, PIECES OF YOUR SOUL
WILL IMPLODE TO FIND ITS WAY INTO ME

CONTENTS

INTRODUCTION

I must admit that up to this point most of my life has been uncertain. I can remember many days when I just wondered. I wondered who I was and what I was going to be. I have spent most of my life living everyone else's dreams. I never realized the creativity I had in me. I had no idea how to live. I don't really think that I know the meaning of life; all that I know is that I've been yearning to find that one thing that gives me a peace of mind. It has taken me almost to the age of thirty just to begin to let go of my fears, my worries, my doubts and to give my imagination to the world. My intentions are to show the world that you have it in you to do all sorts of wonderful things and that your ideas are beautiful. You must understand that everything is subject to criticism, but this book is for those who are starving for a richer life. I call the book "Wet Dreams" because most of the stories in this book came from different situations in my life. In my mind I thought that I must have been dreaming and that those things couldn't really be happening to me. I thought that they were so impressing that I had to share them with the world. This book was created out of love. I have taken situations of my life and carved it into stone. This book is for the lovers, for the ones who want love, and for those who want to continue to love. It's also for you to be entertained, but it's more than just entertainment. It's for those days when you just need to get away, for those days you may want a new approach to your love life. The most important reason why I wrote this book was to show those who believe in their purpose in life my imagination and creativity so they may be inspired to do the same.

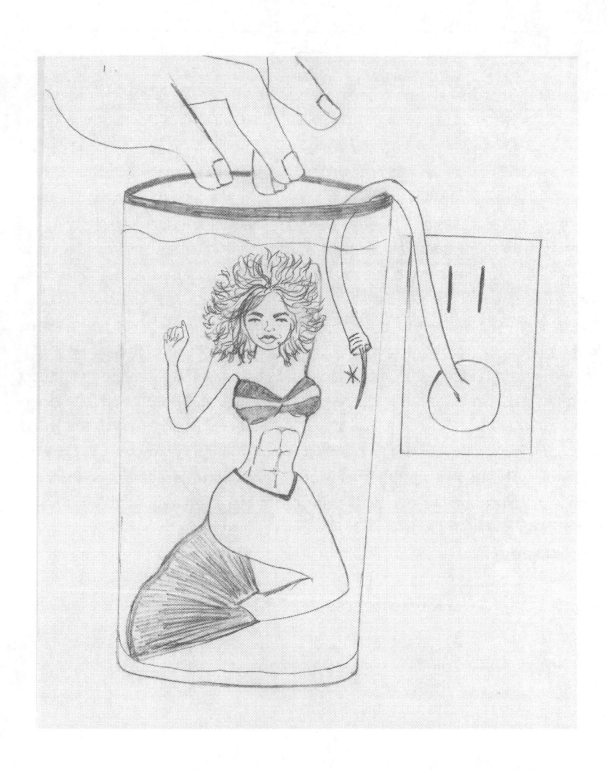

I'LL TAKE THE RISK

He… My purpose is to make sure the hold I have on you when you come
 is firm
 I need to see you take your heart and dip it into a pool of my
 sperm

Her… Oh really, so you're saying that you can get rid of my number one
 germ

He… No, this is not an illusion and no, this is definitely not a mirage
Yes I need the spirit within you to feel my voice giving your body a
 massage

Her… I bet at the end of the night you'll park all your game in a huge
 garage

He… My goal, no matter what, is to take my tongue and build a slow
 pace up and down the bottom of your feet
Hoping to release about ten degrees of your body heat

Her… You probably think that after you do that I'll let you eat

He… I'm serious, I'm not joking around, I know when you're here because
 I can smell your perfume
 But the echo of your wetness between your legs is what my senses
 need to consume

Her… And your ego is big enough to fill an entire room

He… Listen to me I need you to soak yourself in your own bath of pleasure
 just for me. I want every bit of you to get wet, so when you cum,
 don't stop, continue to rub
He… Don't worry I know what I'm doing; I'll prepare you for it
 and have you do it in your tub

Her… I believe that all you really need is a hug

He... What you have to understand is that I'm willing to lose everything by turning you on with my talents. I want all three of your orgasms to happen at the same time, you know, I'm kind of, sort of looking for balance

Her... I bet, cause with you that's perfection

He... I'm serious: I'll give up everything to learn how to always be tender up top, so when I'm stroking you I can make your coochie pop

Her... Yeah right...

He... I'm for real; I'll sacrifice myself to let you finish first, I'm telling you when it's said and done I don't care what religion you're in, you will curse

Her... Right, because with you everything moves from bad to worse

He... You keep it up, and they are going to drive you away from here in a Hearst

Her... You're so vain
You're trying to be a philosopher but you're not!
So just stop! Damn! You get on my nerves
You're insane!

Strawberry Juice

Why were her lips so wet?
It had to be something she ate I bet
Were there others before?
Are you coming?
Is there more?
There are only two
So what are you going to do?
You could always share
One for me and one for you
Hers was juicy and at the roots
It was pink with a little white
She suggested that I use only my lips to bite
When I moved closer to it
I could see the secretions squeezing through her pores
Reminded me of the times I had sex on cold marble floors
It looks too sensitive to be man-handled and beaten
You could tell all it really wanted was to be eaten
I bet it taste so good
More soothing than a cat's meow
Then she screamed out,
"Eat it! Do it now!"
I didn't think I had to be as open minded as Plato
I knew what it was
She wanted me to eat her cherry tomato
I did of course
But I was deceived
It didn't carry the thickness that I'd perceived
It was a little loose
It tasted more like Strawberry Juice

Yellow Tail

Pour it in your wine glass
Fill it up to the top
Okay hold on, wait, you better not let one ounce drop

I love it when I play around with it
Mix it; put oranges, strawberries, cherries and limes
In it to see if it fit

When it runs down the side
I take my tongue and lick it up
Because I don't want it to get away
And after I've had four or more glasses and your bottle is empty I still
want you to stay.

We will both sit back and relax
And listen to the Isley Brothers sing
While I take it and pour it around your nipple ring

There are several reasons why yo yellow tail is better than Coca Cola
One reason is because it's more soothing on your areola.

Girl… I just love yo yellow tail

I want it chilled
And poured over my chest
At night when yo yellow tail is in my mouth
That's when I will realize it's the best

I remember when I met you

That thing that I did
Showing the world how good you tasted
That I could have hid

I sat yo yellow tail right in front of me
Took you straight to the head
I was in heaven
Being blissfully fed

The couple at the table next to us started to stare
Yo yellow tail tasted so good I really didn't care

I'm going to get twelve or more of you to put around my house
It will be a man's greatest fantasy
Like having more than one spouse

I think when this is all said and done
I'm going to hell

Cus I'm on my knees with you in my mouth
Worshiping yo yellow tail

Juice

Three hundred sixty five days
Her lips stay moist always

It tasted better than Mountain Dew
All of that, that runs out of you

I'm ready for the game; I have my bat
I want to feel you run so I didn't bring the jimmy hat

I'm going to keep hitting it moving in the same route
My intentions is to see some spray out

Your chests are so Phat
When I put my stick between them it's a disappearing act

It has a significant source of calories
Especially when I equipment your dildo with brand new batteries

There's no saturated fat
What's saturated is her heavenly made kitty cat

Whatever is stored in your skin I need to taste
Not letting me break your seal would be a waste

I'm excited because I don't have to pay a water bill
It's always there; it has a life time refill

Let it drain, don't hold back, have no pity
My mouth is open so go ahead and flood my city

They are so big and round
The net weight is sixteen ounces, that's about one pound

It's all inside waiting for me to drink
It has to taste like lemonade the kind that's pink

I want to make it run from all three holes
Don't worry I'm prepared; got one of those huge punch bowls

I want to dig it out of you with my shovel
Let it fill up way pass my water level

I want it to drip slowly onto my sheets leaving a permanent stain
 You could even use it on my body to get rid of the pain

I want it to come down on me like I was taking a shower
Let me just hold myself while you run over me for about an hour

You can add me to your cocoa I'll be your chocolate mousse
What I'm trying to say is I want to get all up in and build my destiny in yo
juice

blood is Thicker Than water
period

I wonder when going down on you while you're on your period is a sin.
Because I'm nasty, I'll do it as long as you keep the tampon in.

Blood, you know, is our closest friend and I'm willing to say that it could even be a well known kin.
But do you really want me to come up and you see it all over my chin?

You know it might be a good experiment because your blood is different from your cum; it has a deeper color and a stronger glow.
So when eating you out I might see your blood override how your cum flows.

I try to tell you that your blood is my foe.
But all you do is give me that look, put your hands on your hips and say…so!

I've had sex with you a few times while you were on your monthly and it was all over the place.
Now can you imagine it being like shaving cream and spread all over my face?

You know naturally taking in your cum to me, that's easy to follow.
But drinking in your menstrual fluids, now that's hard to swallow.

Now, I can see why I would have sex with you when you're on your period. I can see the thing I could gain.
I don't think my mind could take me going down on you when you run red like that. That's just insane.

You will say to me one day that you want me on my knees so you can give me your vampire love.

I can see it now. My face pressed up against your red- colored clit fitting like a bloody glove.

I don't intend to fall in love with it or even marry it.

However, I must admit that blood is thicker than water, period.

Pink Lemonade and Vodka

Pink Lemonade and Vodka I'm calling you both up
The three of us together
This is a sight to see
Now before you get here
I will get rid of the Cocoa Berry Smoothie

I want you over and under
I can handle you two
I'm still in my prime
You better hold on to it
Both of you are going to come in my mouth at the same time

I want you raw
Take it straight to the head
Contraceptives, I don't need to buy or borrow
When I'm done
Don't you go anywhere
I want to feel you tomorrow

I'm looking at you through this glass
I know one day
I'm going to wake up butt naked
With you next to me
Laid out on my neighbor's grass

You're turning me out
Wake me up
I must be dreaming
I don't want to pretend
But
I can feel you go down on me
And now I'm running out the other end

I've been watching you way too long
Now it's time to take my shot
I want to feel you travel all the way down between my legs
Yeah
Right there
That's the spot

I don't ever want you to stop coming
Give it to me until I start to float
I think the best part about you
Is when
I put you in my mouth
And you burn going all the way down my throat

I must say
That you two are my special friends
You're the only ones
That knows how to have me coming out of both ends

You are the missing link
I'm so wasted
I swear
You got me in a different position
Every time I blink

We've been here for three days
I know we smell like skunk
But
Right now we all smell like a scented orgasm
Because I'm drunk

I've been drowning in you for some hours
In a few seconds I will let it go
Outside in front of the house
All in your mama's flowers

You always lead me in the right direction
You're my insatiable gypsy
I'll do the both of you
Eight or nine times
When I'm tipsy

Your fluids are made of multiple orgasms
My body can't stop shaking
It's so sickening
But you two together have all the signs of love making

You're like a magical potion
Wait
Take your time
Now
Put it in my mouth
I want you to drain down my throat in slow motion

Pink Lemonade and Vodka
I swear
You are the best
You do just the opposite
You take the hairs off my chest

Spider Web

One day I invited this girl over to my place. We had been digging each other for awhile and finally this was the time to get to know her better. When she arrived I politely let her in. I noticed she was wearing a long black mink coat and black sandals that had a cross strap that went over her foot up the center and laced around her ankles. In the back of her sandals there was a zipper that zipped upward from the bottom of the heel of her foot to her ankles. It was strange because the zipper on both shoes were down. Her shoes gave her feet no support. It really didn't matter I was glad to have her there. By the time I closed the door she was staring me down, and then she rushed towards me and began kissing me. Next she removed my shirt; I needed to know where she was going with this so I played along. I removed her mink and what do you know. She was completely nude I mean she had nothing on but her two nipple rings, a navel and clit piercing, and her powder brown skin. By this time I was down to my pants and underwear. Then she said to me, "Take me to your room." I obeyed her command and took her there. When we got there she quickly removed my pants and push me back on the bed. She climbed over me and gave me more of her kisses. While she and I were kissing, I begin to remove my underwear. By this time I knew what she wanted. She took her hand and moved it toward my penis. I could tell she was curious of how it felt. So she grabbed it. When she did, her eyes widened with fear and her mouth dropped. Then, she said, "Is this real I can't believe it, you know, I think I should go. Because I have a lot to do in the morning and I'm a little tired." While she spoke I noticed that I could see her clitoris from the position she was in. I noticed a white substance creeping out of her clit. It hung from her clit piercing down towards my abs. It reminded me of a spider web, and how she's a liar.

She's mine

I want to make the universe go bang, bang, bang
I'll do whatever I have to do to make it scream my name

I feel it
I'm on my adrenaline
Wait
It's been at least three days
Maybe it's because I haven't taken my medicine

My world within was scorn
Then I became god to it
Now the universe is mine
I allowed it to be born

Keep going
Keep moving
Don't stop
I'm jumping on it
If I don't do it who will
Somebody's got to be on top

She needs to come up with something serious
It needs to be planned
When I come into her
She's going to need a lot of room to expand

That's why I want a lot on my plate
I know she's a big girl
But I can still stand up and hold her weight

Wait
Wait
Wait
Let it flow
Don't let go

Give it to me
I know what to do with it
It's my desire
God gave it to me, wrapped in a big red bow

To reach any dream you can't let it cum alone
I'm always around
Just make sure your head is high and your knees are on the ground

If you hit her right
The universe will always be good to you
She'll never do you wrong
Its like the satisfaction you feel when the urge is gone

It feels so good
The universe is stroking me right
No, I'm not fornicating
I married it

The day I was reborn
She became my wife
Good for her
Because she's in for the ride of her life

PINK LEMONADE

The last time I had her, every part of her I savored
I remembered taking in her last drop, her pink label said she was naturally
flavored

I know for a fact that she's made with real fruit juice
Because after tasting her, my flesh feels enlightened; it feels so loose

Her beauty you might have seen
After her juices have been on the inside I know she's noncarbonated
and has no caffeine

You know sometimes I want to take my tongue and lick up her long label
that says Nutrition Facts
Because I want her to have my stomach moaning and groaning and
doing sinful acts

Sometimes I don't want to use a cup. I just want the whole thing jammed
in my mouth
Because you have parts of me heading north from being down south

If I was a woman I would unscrew your top and slide down on your
neck
I don't know what has gotten into me, I'm addicted, my minds a wreck

Tonight I will have you with dinner; you will be right beside me in my
cup
And before the night is over I will make sure I drink you up

I'll be like the cops and tear some shit up like a house in a drug raid
If anything tries to go down on my pink lemonade

You will always be there; you and I will never fade
 I love you. I really, really do. You're my one and only, you're my pink
lemonade

When I Cum Around
These Are the Things That You Say

You taste like those skittles candies
You ruined my cotton panties
Don't worry about that,
I can remove my bra
I just need something to drink
Oh no, I have a cup
I just need your straw
All that you have inside give me some
Remember that everything takes time
So just relax be patient it will come
All the other memories I have are gone
Because you're the most comfortable seat I've ever sat on.
You do amazing things
I don't have a reason to pout,
You're like a solar eclipse
You block my view of everything when you pull it out
It's been three hours
I have taken your final blow,
I don't have anything else I'm out, fo show!
But I'll take it all if you want to go the back route,
But it's so good it's making me delirious so pull out
Oh I just want to hit you in your chest with my fist because nothing has
ever felt like this
It's so good I can hardly breathe
Is there any chance I can borrow it when you leave
You feel so good,
Damn you fit.
Your mellosmoothe that's running out of me
Is the sign that says I like it
Yo dick is so big it's a crying shame,
See Honey I told you
Look it came
I want you to go to a place that no man has ever been; my back door is
open cum on in

Baby stop!
What spot are you hitting?
What are you doing to me?
Does it suppose to do that?
I feel like I have to pee
You take your shovel and you continue to dig,
Hold on, wait, pull out,
Let me see if it has an attachment,
It shouldn't be this big
Yeah daddy screw my brains out
I don't care,
Come up some
A little more
Yes, right there
It's so good I would love to stay on,
Now put it in my mouth so I can swallow
Look aah… it's gone
When you hear me moan and hum
Ready or not here I cum
You're all up in my rear and I can feel something ripping, shh don't
move
Is that the water faucet I hear or is it me who's dripping
How many strokes will it take to get my liquid bubble to pop?
Try seven
But each one feels ten times better than heaven
I know you have another life
So your dick I had to borrow,
I promise to give it back
After you come tomorrow

Not Tonight

Him... Not tonight baby I'm beat.
How about we pop some popcorn
and watch TV on the living room loveseat

Her... But I need more room
 How about you take the pillows off the couch put
 them on the floor
 I want you to stand up in it; make me scream for more

Him...Come on baby stop fooling around I really want to
 relax and watch this movie I found

Her...Ooh...
 I got an idea
How about you remove everything from the dining
room set
 I want to spread you open
 get it nice and wet

Him...Are you on a natural high?
 Go ahead and tell me what's on you mind
 So I can finish watching sci-fi

Her...Well I have a confession
 I want your back on your desk
 With your knees to your ears
 While I tickle your rear
 In the middle of your business session

Him...Okay, baby
 It's obvious that you're bored
 So what can I do for you?
 It's late;
 there are only a few things we can do

Her... Okay
 Listen to this
 This will blow your mind
 Let's get in the tub
 I'll take the shower head
 put it between my thighs
 and let the water run down my lips
 While you hit it from the back and hold my hips

Him... I'll give you all the love you need later
 how about that
 And you can even wear your cowboy hat

Her... Yes, yes
 we're going to have so much fun
 But
 before we do it
 how about you remove the picture
 above the bed on the wall
 The vibration of me riding you always makes it fall

Him...Yeah...
 yeah baby
 Whatever you need
 Just let me be
 I promise later on,
 I'll plant my seed

Her...Then you can remove the cat from your favorite chair
 Make him watch from the floor
 I'll make this position your very best
 I want my head on you shoulders
 With my back to your chest

Him…Alright,
 alright
 Every word you say I heed
 I won't forget about you
 I know your insides need to feed

Her… I've already eaten dinner
 I'm ready for dessert
 Right here and now
 So remove the plates from the kitchen table
 I want you on demand like Comcast cable

Him…Girl, stop it!
 That's it!
 I'm not coming to bed tonight
 Nope!
 No way!
 I'm sleeping right here on the carpet

Her… Oh, darling
 Come on
 I need to feel beautiful and naked
 Let me take all my clothes off
 and put on my diamonds, heels and mink
 So you can hit it up
 with my legs wide open
 on the bathroom sink

Him…Baby,
 you know sex is suppose to be relaxing
 This is a lot of stress
 It's not fun
 I'm through playing with you
 I'm done

Her…Don't do this to me
 I just want to be more creative
 How about
 you lay me down
 and let me put my feet on your chest
 While you stroke my spot
 and make my juices spray
 on the hood of a car in a stranger's drive way

Him…Wow!
 You are so sweet and kind
 But you know what
 You're out of your god damn mind

Her…Whatever
 Ok
 forget about all that
 Let's just do it anywhere
 I want to scream out to the world
 that I'm your sexual psychopath
 While you beat it up
 Under the overpass
 Up against the wall
 On 96 and Telegraph

Him…Now you're out of control!

Her… Wait!
 hear me out
 I want my thirty minutes of fame
 so let's make a movie
 a short vision of Hannibal
 I want to devour
 and suck the life out of your meat
 we can name the movie
 Cock Swallowing Cannibal

Him…WHAT!
 Sometimes I believe
 You have two sides
 And this is your other half
 I don't know what to say
 All I can do is laugh

Her… I want you in the bathroom
 Sit on the toilet put your feet on the tub
 while I slob your knob
 until you release your load
 I want to watch the cum and spit
 run in between your legs
 and drip in the commode

Him…I don't believe you are a whore
 but your actions are making me wonder
 I don't think I want to play this game anymore

Her…I don't believe you
 Let's just watch the movie you wanted to see

Him…Baby you know I'm just joking
 see…
 feel me…

Her…Oh yeah
 I can tell
 It feels like your ready to bite

Him…I am
 so don't be holding back
 Not tonight

Keep Box

I have her body and spirit in this storage system
Not the small ones
But the new large size
I think it holds about 17 gallons
Let's see
 I think her gloves are in there
Some fake fingernails, a bat
And oh yeah
A picture we took in the Bahamas
With me and her sitting on some rocks
All that is in my keep box

I just love this girl.
I keep everything she owns.
All that she is, is in this nice size case,
I know her bras are in there, panties and thongs.
And yeah
A Dear John letter I found rolled up in her socks.
All that is in my keep box.

You could say it was my personal filing safe.
It might not mean that much to you,
But to me this is my little piece of her.
All those love letters she wrote to me.
Those pictures I took of her.
I keep her face because I love her smile it's being preserved.
And the wedding ring that's connected to the neck of a dead fox
All that is in my keep box

It's like a little room filled with nothing but the memories of her.
Like her clothes, shoes, and cosmetics to go along with her face and smile that's being preserved.
I also put a cute headband around her dreadlocks
All that is in my keep box

She left once. The bat brought her back and now she's here to stay.
I thank God for that bat.
Anyway, I don't think she really meant what she said in all the letters.
The pictures in the Bahamas, I know she really wanted the guy to be me.
All that is in the past, she's with the one she loves now.
I don't think I took a picture of the scar left behind by her chickenpox
I'm sorry, I got to go and check my keep box

You Make Me Crazy

I know she was thinking that he's being affectionate to me
He might go down on me

She was also thinking that I might do it.
She was hoping that I'll pay attention to it.

I want to be exact.
To tell her she's turned out, I don't think I can tell her that.

She doesn't know I already peeped her card.
She gave herself away the moment her nipples got hard.

They were so big I could see them through her bra and shirt.
 Man... they were so big you could tell they had to hurt.

She leaves this deep imprint that said, beware don't impress. When
I'm stroking her, the impression that seems to be permanent appears a
whole lot less.

She puts on this facade...
But I know this is what she's thinking: this thing gave freedom to many
of people, it must belong to Moses, and this is his rod.

I know my liter feels her up.
When I'm submerged inside her, right above her navel I can see the
lump.

She wouldn't admit to it.
She might lose control if she committed to it.

She was trying to be bold.
I could tell she was losing it; her hands were everywhere, She needed
something to hold.

Across my face she gave me a hard smack.
I knew she was feeling it because she stopped abruptly and put her nails in my back.

Man…when she started to stare in my eyes
Then, I knew she was about to explode: she clutched my waist with her thighs.

I thought she was being lazy
No… she was cumming and when she came, she screamed out…oh daddy, only you make me crazy.

I Can't

I can't
I just can't
Be away from you

I wrap myself around you
I feel you
Feel for you
Live for you

I can't
I just can't
Be without you

I need
Our conversations
To develop and grow
As one
To hold you close

I can't
I just can't
Be away from you

I want to serve you
Drive you around town
Take out your trash
Clean your house
Run your bath
I can't
I just can't
Be without you

You are my comfort
My cure
My addiction

I can't
I just can't
Be away from you

Once again
You are my comfort
My cure
My addiction

I can't
I just can't
Be away from you
To be without you

Steak and Potatoes

I want to take my knife
Carve you right out of the world and make you my wife
Umm…carve into that juicy meat
To spread you open to release the heat
You know I like it well done
And your lips will be used to replace the bun
But on certain occasions I like it medium rare
I'll take deep breaths and suck you in because your scent is in the air
Taste so good I could scream
I like to take my tongue and lick right up the seam
Oh and don't forget the mash potatoes with the works
When they are not around I want you to know, that hurts
Especially the sour cream, without them I could develop a stroke that's mean
But when I'm desperate I'll take it rare
Who said anything about me playing fair?
Yeah rare
I promise when I'm eating it you'll pull your hair
Don't do all that fancy preparing
You should know by now I'm quite daring
So just give it to me and let me eat
Let it run through me like whole grain wheat
Can you see it?
The mashed potatoes right next to the meat
Even my orgasms are ready to eat
I realize it's raw
But who said that putting a little red meat in your mouth was against the law?
 I'm prepared to deal with it
And take full responsibility
Because it gives me a sense of immortality
So just give it to me
I paid my price; you have to understand that nothing in the world is really free

I don't even know why I'm explaining it
It's deeper than what you could ever imagine; its heaven sent
Remember seasoning is the key
So give me my mashed potatoes and let me be
I want my steak and potatoes nice and right,
Served to me next to an open window at night
Separate from each other
But close enough to be one another's lover
Steak and potatoes hot and steamy
I want the steak to be moist and the potatoes thick and creamy
Now to me that's foreplay
My steak and potatoes served to me my kind of way

Private Selection

My private selection
Is better than anything
Its perfection

My protection
It's my security
This is the primary reason for my secret erection

My addiction
I crave it daily
To soothe my pain and affliction

My fixation
I need it to care for me
For it to be my rehabilitation

My navigation
Guiding me through dark places
Always giving me the right plan of direction

My connection
I never have to share you, you're mine alone
My prize possession

My location
Only I know exactly how to get to you
You're different from everything else, you're the exception

My temptation
It is so good but so bad
That you put me on your lifetime probation

My private selection
It makes me scream
I love the taste of that damn ice cream

Over & Beyond

my stuff looks like two nice juicy Cornish hens
it feels so good inside of you
it makes you want to have twins

it had to taste good to you
because you started to hum
my replay to you was dumplin you must love that cum

they say we're two peas in a pot
that's because we both know the friction be making that pooty tain hot!

that right there
I had to pay the price
it was like sticking my face in some hot ass rice

I want her to have a whole bunch of kids...sike
but I do want to know what pregnant booty feels like

I don't know why you're acting so shy
you need to make peace with your inner funk
nothing was wrong last night when you were knocking books off the
table
and screaming "I ain't no punk"

when it comes to breaking you off I always win
are you getting dizzy?
that must be yo baby kicking in

I know I'm way out of order
I'll do it anywhere
even on the Mexican border

now this takes courage
not many would do this
just a few
I know I would
and you would too

forget about those Katty Dids
oh…and
make sure you get some oral contraceptives
doesn't matter if it's in your mouth
it still will make you have kids

I've got a few pounds I could put in you
I'm telling you
I'll make you change your whole life plans
I love it when you say "Wow! I don't know what it is
but it's something about your hands"

your breasts keep filling up with milk
don't know why?
there must be a link
your body produces it for one reason
and that's for me to drink

why is it that every time I get close to you your nipples swell
saying that about you is one of the reasons this poem will sell

when you take in my love
it's like corn on the cob
you really can't close your mouth
now I understand
I see why you slob

my imagination and your well being have a close bond
so prepare to be driven over and beyond

Crazy Love

When I'm near you I just can't control myself. I get ghetto and ebonic

I say to myself that girl ….man she got beef and when she smile I just want to take my tongue and lick across the top left side of her teeth.

I'll commit any felony for you just to go to court. When I get there I'll tell the judge," look your Honor I don't even have kids by her, but I love her. I'm just trying to pay her child support."

You know my sexual conduct is so loose, so so loose I often find myself over sexing you and occasionally licking up your booboo juice.

Girl I just love it. I don't know where I come up with this. It feels like I'm having a fit. Aw yeah, come on girl, sit on my face and …um …shit.

When I'm around you I sweat so badly I always carry some rags. Because I keep imagining your breast being pink lemonade juices poured in plastic bags.

I like to play that game where every opening of your body is submerged in cheese puffs. I can only use my mouth to get them out because my hands are in handcuffs.

I want to put it in your rear and when I explode back there I want to pull out and then you can let it drain anywhere. Baby you're with me, remember. So have no fear.

I'm all over you. You're my biggest fan. Plus your sex is like doggy treats it's got me jumping through hoops. Yes I'm your ballerina man.

Girl, your skin is so soft I don't want to mess it up .I don't want to leave a mark. So I prepare myself for it and when I'm sexing you, I wear not one but two pair of gloves.
I must say this is some crazy mess; no this here is crazy love.

You, Me and Everything

It's you I can feel
You can't be real
Your voice I can hear
I don't wonder about you, you I don't hear

To me you can always talk
But you will only hide behind
Everything and pray on and stalk

Nothing about you is you
I'm always looking around to find your clue

I know you receive my email
It's like me you wait to see fail

I've reached the height of heights
Just to belong to your copyright

I'm your book; you have the right to turn my pages
Let me grow inside your love bit by bit in stages

If your heart is cold let me be your load
So when you fold, you can run to me and I'll be the one you hold

COOL DOWN

He…Yeah baby right there
 Girl move your hair

She…It's so big and round

He…You'll be alright after you cool down

He…I just love the way you stare

She…Oh boy you don't play fair

He…You're so soft and brown

She…Stop, stop, stop, and give me a second to cool down

She…It's too much I think I'm going to burst
 Give me a minute I don't want to curse

He…Yeah I see your smile is turning into a frown; so I will
 give you a minute and go back at it when you cool
 down

He…I'm happy like a fox
 I knocked it straight out the box
 Mama I'm not done yet ;why don't you go downtown

She…I will baby later, I'm overwhelmed right now let me cool
 down

she…Baby boy I'm having a fit
 Yeah right there
 Eat it
 Daddy get mad at it

He…Yes my tongue and your clit are bound

She…Okay could you remove your face from my private
　　place so I can cool down

She…You know my tolerance for you I lack
　　So I'm not going to let you turn me over and hit it from
　　the back

He…What! Girl I won't let it suffocate you, I got you, you
　　won't drown
　　Afterwards I'll put you in a nice warm bath to relax your
　　muscles so you can cool down

She…Just put some ice water in a cup so I can pour it on my
　　pussy because it's heating up

He…I've been searching for you for a life time and finally I
　　Found

She…You aint right, I'm going back into hibernation so I can
　　cool down

He…Mama you know you're my saint

She…Oh shit it feels like I'm about to faint

He…Baby we have company, don't make a sound

She…Man… that's impossible you're too damn big but I'll do
　　exactly as you wish the moment you let me cool down

he…Girl move your hands. Why do you cover your face?
　　Just relax you're at my place

She…I'm embarrassed by my actions, I feel like a clown

He...Aw baby it's ok just lay back, let me handle this, cool
 down

She...Oh baby I'm coming, claim yo set

She...Damn ...I'm sorry daddy. I got your thighs all runnin
 Wet

he... Yeah I'm the king, I wear the crown
 And girl I'm going to do it all over again, when you cool
 down

Kitty Kat Cocaine

I could never repay her
I will always be in her debt. I will never forget the day
She served it to me warm and wet

She said her pussy was the tree of life. To eat from it would be a great
sin
If the walls could talk they would tell all the sinful places I have been

Her voice was lovely, the girl could blow
I don't want to send mix signals so what I'm trying to say
Is the sweetest music she has ever gave started from down below

She told me if I ever wondered, all of it she has caught
Now every morning when I'm eating breakfast I ponder over her words,
now that's food for thought

She held it in her hand, then she said that she didn't quite know what
to do with me. She needed to do something before she said good bye
Therefore, she took it and slowly began to suck it dry

I told her that whatever it is she needs to know she could tell me
That's if she wishes to do so
But if she chooses to
Through doors that are in the distance is where my fluids will go
Because the last conversation we had she felt
It was like I had somehow changed the cold
I took her out not to thaw but for her inside to melt

So the next time I call she'll be like Halle Berry
In Monsters Ball
On the phone saying I want to feel good, make me feel good
That's what she'll say when I call

She said that her love is covered in gold and to a certain extent that's true
But my taste buds said that your meow baby is made of platinum that runs all the way through

Please tell me how you like it I would love to hear your different voices
Don't worry about me I'm equipped with a number of positions so you have many choices

Her eyes told me I had an indescribable stroke
She then told me that with each moan more of the dead she woke

My love she told me she could ride all night never wanting to stop
I told her that was just wonderful because in addition to that there's about 300 ways to always get her to stay on top

At night when I'm holding her I do believe she feels like I'm her winter's fur
Nine times out of ten after sex she'll fall asleep with me still inside her

You know I'm desperately trying to know more about you it's much more than a want it's a need
I figured out awhile ago that when your eyes get glazy like that the DNA in my come you read

She told me that her and her mind is constantly in a battle
For the life of her she can't stop thinking about having a threesome with me and my silver shadow

I think I have to stop this, I can't continue to inject her and stay sane
I'm totally dependent
For the rest of my life I will always call her Kitty Kat Cocaine

Dirty Mind

Him…I'm sick of it
Every time I tell you you're fine
It's always gotta be something
Why can't I give you a compliment?

Him…What!
Why do you think I'm always trying to do you?
You know what
Screw you

Him…Like when I bring you flowers and candy
I'm just trying to be kind
But no
You give me this look

She…Cause you're a Sagittarius
I know your type

Him…I know where you're going with this
I don't have a dirty mind

Him…That day over the phone you ask me what I was doing
I said nuttin
And What did you say?

She…I think I said are you doing it now

Him…See you're the one who's rotten

She…No

She…I called you cause it was a sign
After you said what you said
I knew you had a dirty mind

Him…Like the time that porno played on cable
 Remember
 The one we saw

She…Wait right there you were trying to be slick
 You wanted to hit it raw

Him…You've gone too far
 You crossed the line

She…Don't get mad at me
 You're the one with the dirty mind

Him…Remember that day we had a candle light dinner
 I was playing R. Kelly's Bump & Grind

She…Then you wonder why you didn't get any that night

Him…Because you be trippin

She…No because you have a dirty mind

Him…Like the time you wanted to cum alone
 I told you to take a ride
 I mean you were by yourself
 I was concern
 Somebody has to be on top of things
 Why can't you believe me?
 I don't have a dirty mind
She…Boy
 Wake up
 Hello
 I'm not blind

ALWAYS WILL

Therapist…So tell me about the dream
You said you felt crappy
Then when he came around you began to feel
happy

Patient…*Well, the dream started out where we both were in*
the shower
I don't know why but I was upset with him
Then he began to bend me over
He starts to gently submerge himself inside me
It felt like he was breaking me in half
It felt so good I couldn't breathe
All I continued to do was laugh

Patient…*I don't think I could live without his chocolate pill*
I need it
I think I always will

Therapist…Your words continue to be progressive
And I'm quite sure your thoughts are aggressive

Patient…*I can't stop thinking about how nice it would be*
When his last name becomes mine
Can you see it...? Leah Hill
I will love him forever
I always will

Therapist…You mentioned that his liquids have the ability to
Heal

Patient…I'm quite sure when he's 90 and I drink in his
creamy stuff I'll become new
I always will

Patient…*He turns me on so much that my satin tissue stays*

Wet, It's permanently lubed
And his creamy stuff is fused to the wall of my
fallopian tube

Therapist…So you're telling me that his liquid has a lot to do
 with you never being ill

Patient…Yes!
And after I'm dead and gone the creamy stuff he
sprays up inside of me will continue to live
It always will

Patient…because when it was inside me it felt like a huge
 piece of steel

Therapist…Wait, wait, wait don't you think your going too far
 Shouldn't that hurt?

Patient…Yes it did
 But that's how I like it

Therapist…I bet you always will

Patient…I like that risky shit too

Therapist…Like when you slid down on a Smirnoff Premium

Patient…It had me moaning and groaning
 Sound like I was sucking in helium

Therapist…Okay

Patient…That's the way I always want to feel

Therapist…I'm quite sure
 You don't have to worry about that
 I bet you always will

Patient…All of the cum that he ever gave me I saved up
　　　　It's on the top of my cabinet shelf
　　　　It has a factory seal
　　　　It will stay that way

Therapist…I bet it always will

Patient…Even all of his used condoms are in there too
　　　　With all the dates he had me written on the outside
　　　　of the glass
　　　　It's funny
　　　　Cause when I touch it His energy I can feel
　　　　I'm so excited I want it to always be like this

Therapist…Calm down
　　　　It will
　　　　It always will

Therapist…How long are you going to carry on with this?

Patient…I know you probably think I'm delusional
　　　　But the thoughts I have of him and I are really real
　　　　You seem to be a little paranoid
　　　　No one has to know
　　　　My lips are sealed

Therapist…I hope they always will

Therapist…Maybe you need to start seeing someone else

Patient…Please don't say that
　　　　You can't abandon me now
　　　　With that I don't think I can deal
　　　　Let's sign a contract saying you always will

Therapist…It has been a year now
　　　　Don't you think it's time for you to move on?

 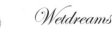

Patient…NO!

 Why are you so concerned?
 Look at it this way
 You have the better of two worlds
 You will always get this juicy stuff
 Plus, I will always pay my bills

Therapist…Yeah

 I hope you always will

Fat Bastard

I think she wanted more
It got her so wet
Oh...
I think there's a web site called www.fatbastard.net

When it's in me it makes everything so pretty
You're so fat
Each part of you has its own subcommittee

I will drink the bitter sweet fluids
This means I will give up my pride
You must bear the weight
It is a heavy ride

Is that a tattoo?
Is it of a pig?
I have only one question
Why is it so big?

She said it tasted like strawberry jelly
After she was done she told me to put my ear up to her stomach
So I can hear it swish around in her belly

I don't want to do anything but watch it all go down through that mirror
It's not painful and only takes a few minutes; pay close attention and
watch my tongue give you a pap smear

All man here it comes pour it in my cup
Get ready rough riders mount up

She said you got me plastered
Damn you
You
You Fat bastard

 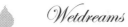

I wonder what the ingredients are made from
Ok, I'm getting a little impatient
Stop holding back and give me some

She said that fat bastard always helps me reach my peak
Just the thought of it in me gives me dick leak

To her that fat bastard is her biggest fan
For her pleasure it goes by the name Jake and the fat man

Hurry up
Stick it in
Pop the cork
I thank the heavens it don't taste like pork

She said that fat bastard be all up in
Oh…
It's gon' put me in the Guiness Book of World Records
For committing the biggest sin

This fat bastard is putting the pressure on you
Keep messing around with it
It's gon' break your pelvis that's what its gone do

She said yes you fat bastard break my back
Yeah baby shucky ducky quack, quack

You know I don't care what it might be
I love it when that fat bastard makes you say anything to me

I Adore U

I know your heart is sore
I can make you feel like never before

Whatever it takes to make you happy
Whatever it takes to make you smile

She said if I were physical
I would lubricate your penis with my soul
So the next time you're outside and it starts to rain
It's me coming over you.
This is what you do to me for being so bold

When you're weak
And you've reached your peak
I can feel your pain
Only you and I know why the sun shines in the rain
It's your intense heat stroking my string with a long
And soft beat making all my liquids leak

She said that I was like an earthquake
So angry and upset
I've notice that it never alters the way she flows
Just pay attention to her mornings
They're always wet

I told her that her summer sweat from her pores is what I wear
Then she said that's why the earth is thirty percent land
Because I spread her watery substance everywhere

 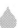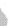

She's so good to me
When in need she lets her love fall
She doesn't fight
Especially in the dead of winter
She colors everything creamy white

She told me that I am never the same, I'm constantly changing
I always alter her seasons
She said" it's like you placed an ice cube in your mouth
And then I felt your wind blow"
She said" never doubt yourself, you're the reason why my rain turns
into snow"

She's my summer's breeze
Her luke warm texture
Keeps me on my knees

And when the midnight falls
It's just her turning out the light
She's asking me to come to her beach to lie on her wet sand.
Doesn't that feel so right?

She told me that I was her embryo lotion
When I'm rubbed around her intimate opening
it feels as if she's born into me
She literally feels my motion

My water based element set her rivers running
she said I must be made with some kind of special potion
because I'm the one that created her Atlantic Ocean

Every time you suck the air out from in between us
you ignite my storm
can you feel my rain drops
do you hear it
every time you hit it
it pops

I've always wondered in autumn
why the leaves change color and fall
I know now
it's your love gathered up
and placed on the leaves
in a huge liquid ball

It's your destiny
your fate
no one
absolutely no one
can hold back from your watery weight

What she really need

Is for her walls to be wet
And to watch the motion
Of my silhouette

My kisses to be her permanent tattoo
And her heart to stick to my chest like glue

To love her in different places
And to be entertained by her different sexual faces

What she really need
Is for me to sit around her so she can smell my scent
And to be a permanent replacement

To give her a sexual healing
And to give it every time she gets this feeling

To give her something deeper than my soul
And for me to fortify her
Is her goal

What she really need
 Is for me to eternally be her better half
And for me to bathe her while she takes her bath

To physical place her in my Garden of Eden
And never come out
To stay in
And keep eatin'

To discover her spot that makes her back arc
And for me to do it all in the dark

What she really need
Is to be comforted by the morning sun
And for me to add to it by making her liquids run

To take away her pain
And to put my hands right there to initiate the rain

For me to know that her body is sensitive
And for me to stalk it by being attentive

What she really need
 Is for me to have her wide open
To protect her when she runs out is what she's hopin

To help her be the best that she can be
And to make her love flow so thick
 Even in the dark you could see

What she really need
 Is for my passion for her to make her cry
And to be her antibiotic and make the negativity die

What she really need
 Is for me to allow her the book to my body so she can learn
And for me to realize the desire she has for me continues to burn

Chocolate Pudding

I realize you and I would be a perfect match
So I decided to make you from scratch

Three cups of milk
I can feel you through my thoughts and these three cups will make you
as soft as silk
I have my own recipe
And you're better than Sara Lee
So when I eat you and every time I'm eating you, I want my taste buds
to scream louder.
That's way I added one third cup of sweetened cocoa powder

I have your chocolate simmering over the stove
Now I have to get my footing to add in the pudding

I know just what to do with you, when I'm through with you

I had a pudding dream
I had to call you up
So you could cum
Because I needed you to add in the cream

I must admit I do have a vendetta
It's to slowly stir into you one teaspoon vanilla

I will be patient
Because I want you to come again
And it will happen soon as I put in the three tablespoons of margarine

When I brought her ingredients to a boil
I came to a halt
Now that she has reached her peak
It's time to add in the salt

I like the way it felt
I was saying that to you while staring at the candles that were lit
The part of you that satisfied me said it enjoyed the way I put my spoon
in it

Your chocolate pudding makes me put a sign outside my door that
says "gone fishin"
Because your secret ingredient is my nocturnal emission

This might take all night but I'm not in a race
I'm going to put into you everything that's good and do it in a brisk pace

There's one ingredient that I put into you that I won't tell a soul I'm
keeping
I skeeted it in you, stirred you up and left you wet and steeping

Even my spirit had to masturbate, it spreaded heaven all over you
leaving you to macerate

My mind keeps going in this mental loop
Maybe when I'm done she'll let me taste her chocolate soup

To hold you over my face and not be tempted by you helps me get
stronger
You know how I feel, eat chocolate and live longer

When I saw her indecent ingredients
I made sure everything I needed was hot and wet
All I could say was that's a lot of cho-co-late

All that chocolate pudding could get you sick
I can't help it, you know I like it thick

Just watching you, I know my hands can come in handy
Because chocolate outsells all other candy

Every time I eat your chocolate pudding I physically grow
I'm not even going to lie...you increase my libido.

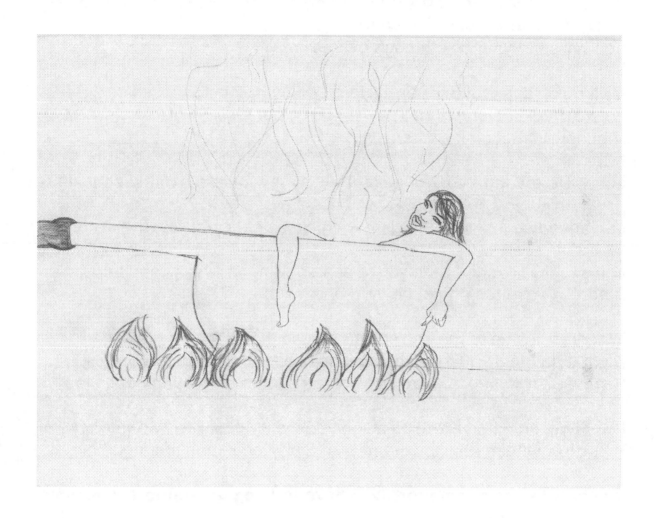

Confident

When I call you up and tell you that I've got Yellow Tail Chardonnay
along with the sound of Maxwell
You will send your sex through express mail

Giving you some of this Mikes Hard Lemonade on the rocks
You're drunk! Figured that out when you greeted me in black see through
lingerie with hot pink socks

You were trying to control it but the way my tongue expressed itself is
now turning you out. I knew it would!
You advertise it by continually buying cases of Liquor Good

You say that it might hurt; you're scared to bend over I keep telling you
it won't; you're too drunk, far from being sober

When you came to me and said that I had the skills you needed
Right then I told you that you must be filled with dedication
Because my school of hard knocks has a lot of continuing education

I have never tasted anything as good as you, I feel like I want to cry
You know what it reminds me of, that Sara Lee lemon meringue pie

It seems like from time to time I have to bring you up to status, your
memory is a blur
But when you open your butter pecan ice cream
And I stick my spoon into it everything starts to register

I know that you're grateful
I also know that you're addicted
You're never satisfied
I'm not mad at you because you always keep it fresh
Making sure your stuff is never set aside

 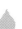 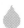

You do more for me than you do your own kin
And by the way I have seen your calendar
It has all the days you're going to pleasure me up to the Fall of 3010

My oven is on 400 degrees
And your body is ready for my mouth to bake
Don't worry when I'm done, I'll be the only one eating your strawberry
short cake

No matter how dry life seems to be
everything about you continues to get wetter
I think you realize that life with me is better

do you feel that
I created your condensation
my face is always an inch away from your private place
you truly believe I'm your biggest temptation

I can see that you're losing it
you're going insane
because my touch is making you use God's name in vain

I want to feel the heat from your pores when I'm cooking you
I like you to be done before I remove you from my frying pan
And you wonder why I do this
here's the answer
Because I can

Vain

I try to get away from it but it holds me back

Sometimes I have it right next to me when I'm lying in the sack

I have another one, one I can hold for those moments when I need to
check out my back

Sometimes my lady wants me to come to bed so I can hold her, but
she has to wait so I can check out my shoulders

They say I'm that word that starts with a V
But when I catch a glimpse of myself, I just like what I see

One day something bit me and I got alarmed. I had to go run and see
and check out my arms

When touching it, you have to follow certain laws; it's got to be this way
because it has no flaws

I don't want to be anywhere no one else has been; cus I just don't want
anything touching this chocolate skin

You should be grateful I'm around you see
Because if I were you, I would kill to be with me

When I'm on top doing my thing, you better play fair. I'll get mad as hell
if I just got a cut and you go and pull my hair.

Let's be honest when we're alone and we're sexin, it's not you that
turns me on, its my own reflection

I was dating this one girl her name was Shakira. She thought she was
fine as hell, but she eventually got the point and left me cus I stayed in
the mirror

I Can Get It Hard

You're trying to impress me and be more than what you are
with all those bras you're stuffin
because you know I'm that Mandingo Stud Muffin

She said that she can't mess with me
because I'll have her pulling all her tricks out the hat
she'll be so delirious everytime she hears my voice
she'll say turn that up my future baby's daddy made that

She looked at me and said "I bet you can dance all night
cause you're a young buck"
I told her she better be careful
messing around with me; I'll have you walking like a duck

But her boobs were so big
you couldn't hold one up with two hands
I guess she said forget securing them today
and she tucked them in her pants

You think I do this for my health
well...actually I do
everytime I read this it feels like I'm having
sex with myself

So here's a clue
if I were to watch us have sex through a mirror
what do you think would turn me on the most?
watching me or watching you?

One day she said to me that there was more she had to give
she wasn't close to being done
but I had to run
so I told her I needed a sixty eight and I'll owe her one

she got mad of course
and went on to say that my dick was little anyway
first of all,dick is too small of a word
that describes what I have
I have the leanest,the meanest, Penis

I guess she called herself apologizing
because she said
"I know that ever since she tried to cut it off
you've been scarred
but if you give me about three seconds
I promise you
I can get it hard"

You Mean 2 Say

you talk to me physically when I'm licking you up your back
your body says so many things
but you
never tell me that

kissing your gorgeous lips is like tasting fine wine
but what's going on with you
what's really on your mind

You like it when your nipples are in my mouth
because they start to swell
that's how I know it's true
but tell me how it really feels to you

When I'm in between your legs
are the noises a part of your game
or is it just a cover up for how you really feel
when you want to call me out of my name

when you met me you might have thought
I was tall, groomed and classy
so what's in your head when my face is in your rear
you might be thinking how nice and sweet you thought I was
but the only thing you seem to say is
boy you so nasty

Sometimes you look at me as if I'm a piece of meat
are you thinking that you have a porterhouse steak
right between your legs I could eat

You say, you could never truly submit to anyone
so the ribbon of commitment you could never cut
but you have to release it somehow
that must be why you tell me to take it out
and put it in your butt

Have you noticed that everything I do your body seems to obey
I know you really don't want to completely let go
that's probably why when you're in the mood you jump right on it
and forget about the foreplay

I know you like to sit back, make jokes, and laugh
but I really think that the only reason you take me in and swallow
is because that's the only piece of me you know you can have

You know ,like I know I'm not like the others
I'm far from being the same
that's why you move real slow
when we're playing the see-saw game

I know I have a 4.8 cylinder under the hood
that's way you put your face in the pillow and pull up the sheets
because it hurt so good

you said it felt so good but you didn't want to continue to play
so I stopped and you said more
so what did you really mean to say

Just What I feel

I came here to love not fight
Loving what I love is my right
I've never been political
But some say I'm critical
They say I over do it
They don't get it
They don't see the sign
Damn
I'm so fine

When you see me you say sexy man
He has nothing to hide
I wonder if people realize that I look at them in the same way
So let your body be my biggest fan
I know looks aren't everything, but I can't fuck your spiritual side

I can sit here
And every minute on the hour I could verbally hand you a different flower
In the same stroke
I'll take them all back
If I see you leave the house without taking a shower

I like the lady of mine to be elite
If I had an issue with you
I would try to be very discrete
I would tell you something like this "hey baby I want to do something, something for me, lets go get in some water so I can wash and scrub your feet
Cause…
We could have problems if it felt like you've been walking on coals that were laid over 100 degree heat

Always try to prepare yourself as the perfect dish
Wearing the same clothes for three days is not what I wish
Got a visual!!
Diving into the smell of raw fish

Before I do anything with you I will always look at those little things first
Can't imagine someone stroking my back
And their hands are rough

 If you ever start to look like a horse strapped with a saddle
Oooh!
You'll be swimming up shits creek without a paddle

Me personally,
 I could have on a pair of Kenneth Coles
With black dress socks
And a wife beater with holes
I know you'll still want to get me in the sack
Looking past all that
Imagining your tongue lacing up and down my back

And when I have sex
I come correct
I workout
And train
Like I'm competing in a tournament
You already see me being around for Christmas
Hanging butt naked from your tree
As an ornament

I make sure I stroke it with a motion
You wonder why after it's all said and done
Your cum is as thick as that …um Lubriderm lotion

I came here to love not fight
Loving what I love is my right
I've never been political
But some say I'm critical
They say I over do it
They don't get it
They don't see the sign
Damn
I'm so fine

I'm always good for the sight
Even if I came around in a towel and some Timberlands
Picture that
Lime green
And white
My hands are manicured
My feet are pedicured
And since I have a lot to lose
My mind, body and soul is insured

I'm a different type of rain droplet
I'll get you all wet
Plus make you smell so good
You'll be eager to know that scent
Wait…Relax…
Keep your panties on
It's just cocoa butter chocolate

Wondering why you love to give me head
I'm pretty sure it's healthy for you
Knowing it taste like butter top wheat bread

You crave to be my only guest
Fantasizing of me spreading my liquids on your breast
I bet it'll look like heaven coming all over your chest

I got to be at my best
So I can be the nighttime
Moaning
Groaning
Yelling
Back cracking
Coming
Sleep better
To feel better medicine
So you can rest

I came here to love not fight
Loving what I love is my right
I've never been political
But some say I'm critical
They say I over do it
They don't get it
They don't see the sign
Damn
I'm so fine

So to me perfection is not necessarily being right
It's what I want and need
So you could look like you've been playing in mud
And have holes in your clothes as if you were trying to jump over a white
picket fence
It wouldn't matter
If I love you
I love you
To me it just makes sense

The Subconscious Mind

I got to get over
Is what you tell yourself
Can't quite understand why the attraction is so permanent
Let me help you see your reality
The little things are important
I will concentrate on the thing that's deeper
Learn to read me so that me you can learn
know why I'm exceptional?
I'm able to control it
It's the thing I accepted full responsibility for
That's why I drive you from within
You already accepted and you believe in my control
That's why it has become your reality

You are what you believe
And all of your behavior is expressed by who and what you think you
are

You believe that I am your protector, provider, guide, your warrior,
adventure
And a conqueror
the make up of a man

That's why your behavior is expressed in a way that every time you
cum you scream out "SOMETHING GOT TO CHANGE YOUR MIND".
Trying to find a way to fit into my grooves

Regardless of what you see yourself to be
You always dance to the tune recorded on your mental tape
And your tune is recorded on the edge of my stroke and the tip of my
tongue

Only because this is what you keep telling your mind you want
You allow me to create your reality
That's why I will continue to grow and learn to learn and grow
To see in your eyes the mental attraction that will always have you
dripping with the wetness of wisdom that hangs freely from your
oversaturated thong

The key to stimulating your fluids is to learn to be more aware of your
inner communications

So your waters move in the direction that your mind tells it to move
I control the valves to all your leaking cells
Because this is what you want
Generally this is what you expect so this is what you will get

Your world revolve around me because you believe in me
You realized that all I have given to you has not been seen nor heard, it
has been felt
That's why orgasms happen all around you

The way you react to my stimulation is very important
So your body language I always have to stroke
And your mental thoughts I always have to prey on

My experience grows the more I'm surrounded by your atmosphere

You wonder why you love me a whole lot more than I love you
There is only one reason
I love me a whole lot more than you love me

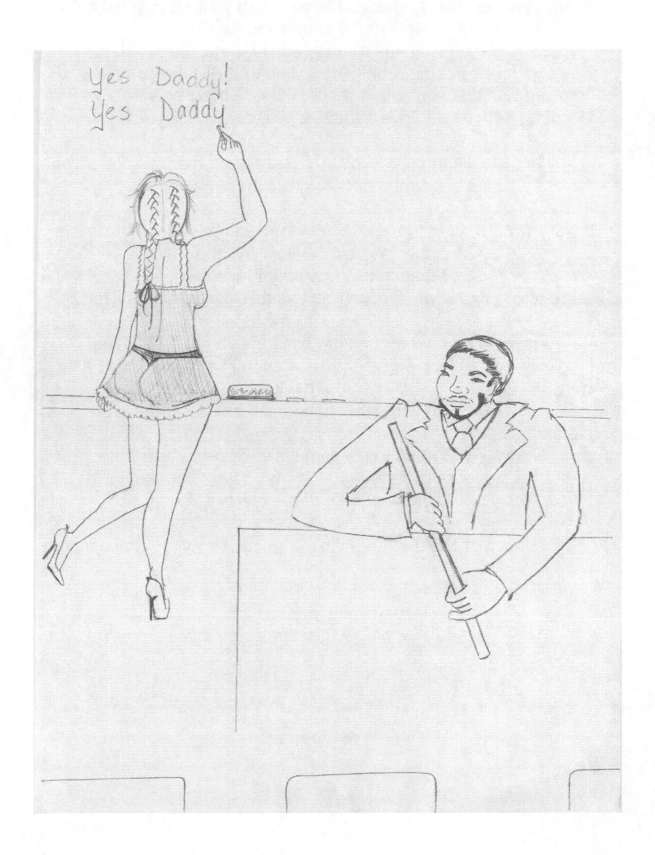

Yes Daddy
The Re-hit
(Hit once...hit it twice)

He: Umm girl you feel so good
She: You feel good too.
She: Daddy you're my tiger, the way you ravish me
She: Umm… kitty, lick me clean.
She: Here kitty, kitty, kitty.

He: Tell me who can do it better
She: No one but you daddy.
She: You're my golden shovel,
She: The way you dig into my insides.
He: Really baby?
She: Yes daddy

He: Take this king size payday
He: It's about time you paid me my rent
She: Oh, I love the things you say
He: Do you baby?
She: Fo show, yes daddy

She: Aw, yeah…tap and blow
He: What are you saying?
She: I don't know
He: Well I'm gonna make your clitoral juices jump around the room and
 look like confetti
You know what I mean girl
She: Yes daddy

She: Daddy you're my only company; you know why?
He: Why baby?
She: Because your dick is good to me.
He: So, I hold the key?
She: Yes daddy, you know you do

She: I think I love you; I'm done looking for another. I'm through
He: For real?
She: Yes daddy

He: This is love right here between your legs
She: Daddyyy....
He: Yes girl
She: If you don't stop I'm going to wet the bed
He: You have my permission to do so
She: Alright
She: Ok…
She: Yes daddy

She: You feel way too good
She: Daddy, please help me figure this out
He: You know what it is, stop being petty
He: Cum right now for me
She: Yes daddy

He: Keep stroking just like that
He: In about two seconds it will be ready
She: It's overwhelming
He: Hush yo mouth
She: Yes daddy

She: Daddy, oh daddy
He: Yes love
She: You know I have a built in water fountain, and your hand is
 pushing on the lever, cus I'm about to cum.
He: Damn, really baby?
She: Yes, daddy.
She: Oohhh, yess daddyyy

INSIDE

I need her to come
Her body would have a triple bypass orgasm
Then minutes later she'll have a permanent one

She puts herself in a place where she can always give her all and my
pubic hair was that same place she used for her rain to fall

The more that I talk the stronger her storm gets and each one of her rain
drops would have orgasmic fits

Her lips has a tender and warm texture if you hit the right spot it will erupt
with nectar

I would look into her eyes and I could literally feel her creamin now she
believes in a unique taste called pecan semen

In the spring her legs will blossom and in the middle will be her seed
anxiously throbbing for my sperm to feed

If I could lick your kisses off the side of my face with my tongue I would;
to pump my productive gasoline into your amniotic sac, I think I should

I love how I make her pussy purr and all I had to do was bottle up my
scent, shake, and stir

The moment my lips touched hers her expulsion was amplified and when the blood in her lips swelled that's when I knew she was satisfied

Her orgasmic syrup has only been given to a few I remember the day I was chosen she said open up here's your morning dew

My liquid love flows in masses to pull out her pleasure cells as it passes

Her inside took me hostage so most of me, her walls had to keep. I don't think she understands that my liquid formula has that drowsiness to put her to sleep

My spermicidal hurricane is a system that purifies; So when I wash over her all of the cells attached to her walls my come will sterilize

There is a reason why the moon shines at night. Because submerged in my lady's secretions are particles that give off a luminous light

When I kiss her I want her saliva to get all over my tongue I want it to be just like cancer sticks and have her chemicals stick to my lung

For her fluids to rush out of her to be closer to me is pure bliss. Now her wetness is laying on my thigh in a unconscious state of happiness

Phenomenally Foul

I told this one particular person I was interested and I wanted to get to
know her better. She was pleased and said the only thing I needed to
know was that she wasn't a hoe.
She said the only thing nasty she has ever done was share a dildo

I told her to please tell me that it came two to a kit
She said no. We cleaned it off when the other needed to use it

I told the girl to take a bow
Because that there is phenomenally foul

She said she doesn't want a man to look down on her after he gets her
to bed
but the only time that its justified is when she's giving him head

She wanted me to give her a "spicking"
I said "spicking" what is that
She said I want you to spank the spot you spit on
I said like this
She said just like that

She was on her knees and said baby I love your lifestyle it's the
cleanest
Plus you're so big I'm going to call it my Bruce, Bruce penis
I asked her why was she playing with my meat like it was a bell
She replied by saying the sound it makes when it hits your thighs gives
off a pleasant ring
Isn't that why they call it a ding-a-ling

You know what's sad
I overheard this man telling his girl he loves her so much that he'd lick
her pad

911 I think you need to dial
Because that's just phenomenally foul

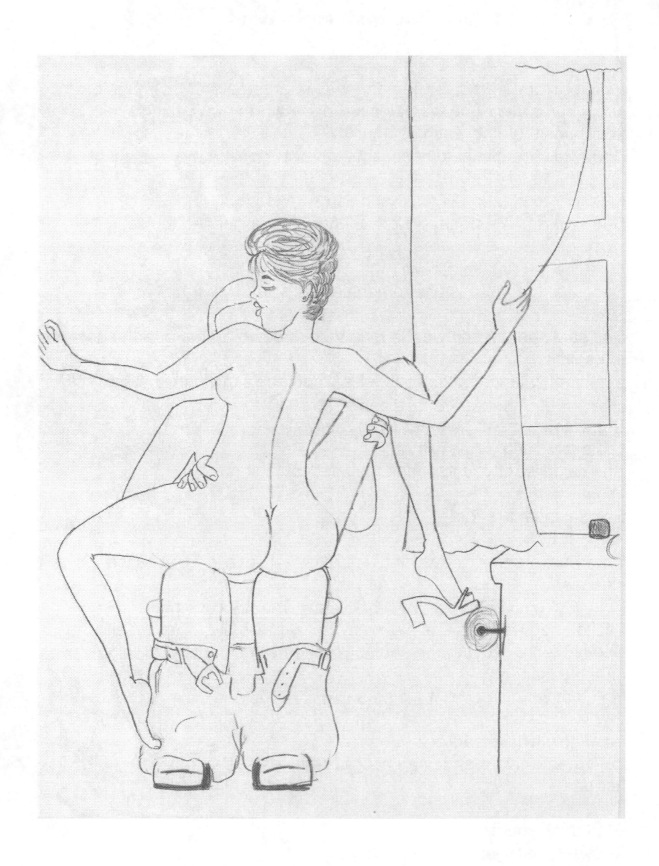

ACKNOWLEDGMENTS

To my mother who has given me all that she has. Your life has given me the strength to move to a higher level of being. You have taught me that time is the most precious gift that God has ever given because within time you have all the opportunities to mold life however you see fit. I love you because of many reasons but mainly because you always knew I was something remarkable.

My sister, Nicky...thanks you for supporting me and helping me to survive. When I felt all alone you were the one I could turn to. You were there to cry with me, you were there when things were hard and I'm grateful for you.

Julie...My friend, my editor, your gifts extends far beyond this world. You are something wonderful. Your understanding and support has helped me to release my dreams. You are everything and so much more and for you to be a part of it all I thank you for.

Shelly...you have shown me life in a way that I never imagined. You opened my eyes to a better part of me. I can truly say that my life began the day we became friends. You will continue to have a place in my heart.

Christl...your organizational skills has been the foundation to my success. I truly appreciate you.

Dondi...your art has given me the imagination to be more creative and I thank you.

Tamarie...you have been there from the very start. You have seen my heartaches and pain, my laughs and my cries. You have been there through the rain and that's a true friend. So, I thank you.

Brad...Thank you for being positive. Your energy is what the world needs. Continue to bring out the best in you.

Mike & K.C.I thank you for always inviting me into your world .We have known one another for many years and have done a lot and seen a lot together. And we will continue to see much more! Always stay together.

Mike & Kim....You are the meaning of what life is. You have opened your heart and made me your own. You enjoy my time and I value yours....Thank you.

Willie & family...thank you for your support and mentoring. My real father was never in my life and you are the closest man to me. You always feed me words of growth and your heart is pure...and I thank you.

Mernaia...you have been the biggest part of it all. You took my imagination and you brought it to life...you are a success and I wholeheartedly thank you for being a part of my dreams.